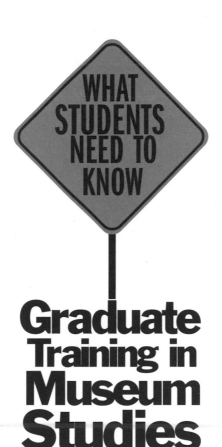

WHAT STUDENTS NEED TO KNOW

Graduate Training in Museum Studies

by Marjorie Schwarzer

AMERICAN ASSOCIATION OF MUSEUMS

Published in cooperation with the AAM Committee
on Museum and Professional Training
Washington, D.C.

Marjorie Schwarzer is chair of the Department of Museum Studies at John F.
Kennedy University, Orinda, Calif. She was previously the director of education at
Chicago Children's Museum and associate director of development at the
Children's Museum in Boston. Marjorie is the author of numerous articles on the
museum field, including such topics as: airport museums, architecture, visitor
services, and multiculturalism.

Library of Congress Cataloging-in-Publication Data

Schwarzer, Marjorie, 1957-
 Graduate training in museum studies : what students need to
 know / by Majorie Schwarzer.
 p. cm.
 Includes bibliographical references and index.
 ISBN 0-931201-74-8
 1. Museums--Study and teaching (Higher)--United States. 2. Museum
 techniques--Study and teaching (Higher)--United States. 3.
 Museums--Employees--Training of--United States. I. Title.

AM11 .S34 2001
069'.071'173--dc21 2001022384

CONTENTS

ACKNOWLEDGEMENTS

M any colleagues have generously shared their insights about museum studies training with me.

They are: Anamarie Alongi, exhibitions coordinator, San Jose Museum of Art; Susan Baldino, director, Museum Studies, Florida State University; Leslie Bedford, director, Leadership in Museum Education, Bank Street College of Education; Tammy L. Brown, graduate assistant, New York University; Greta Brunschwyler, director, Novato History Museum; Bruce Craig, director, research and planning, Smithsonian Institution Center for Education and Museum Studies; Christie Davis, art and public programs manager, Lannan Foundation; Joy Davis, cultural programs manager, University of Victoria, British Columbia; Ildiko R. DeAngelis, director, Museum Studies Program, George Washington University; Gary Edson, director, Museum Science Program, Texas Tech University; Lyla El-Shamy, exhibition developer, California Academy of Sciences; Ellen Endslow, curator, Chester County Historical Society, Pa., Erin Friedberg, graduate, Museum Studies, Florida State University; Hugh Genoways , chair, Museum Studies Program, University of Nebraska, Lincoln; Murney Gurlach, executive director, Rhode Island Historical Society; Carlo Lamagna, chair, Department of Art and Art Professions, New York University School of Education; Stephen H. Lekson, curator, Museum and

Field Studies, University of Colorado; William MacGregor, assistant chair, Department of Museum Studies, John F. Kennedy University; Karen Nelson, art educator, Oakland Museum of California; Melissa Rosengard , executive director, Western Museums Association; Jay Rounds, chair, Museum Studies, University of Missouri St. Louis; Lois Silverman, professor, Department of Recreation, Indiana University; Gretchen Sorin, director, Cooperstown Graduate Program; and Kristin Szylvian, associate professor of history, Western Michigan University.

Special thanks go to the students, alumni and faculty at John F. Kennedy University who have been open, generous, and candid with their opinions about graduate education in museum studies.

PREFACE

I have had the privilege of working professionally in the museum field for almost 20 years and have found it to be an immensely rewarding endeavor. This booklet aims to help you assess training options in museum studies, so that you, too, will go on to an exciting career in the museum world.

It does this by posing a series of questions organized around three broad themes: 1) questions to help you get started; 2) questions about the field of museum studies; and 3) questions to consider when researching different museum studies graduate programs.

The paths to enter the museum profession and the approaches universities and other training programs take are as varied as museums themselves. My hope is that this booklet and the resources listed on page 73 will help you to find a path that best suits your needs.

Marjorie Schwarzer
Chair, Department of Museum Studies
John F. Kennedy University,
Orinda, Calif.

INTRODUCTION

One of the most important decisions a person can make is which career to pursue. Once that decision is made, the next questions are how and where to acquire the proper education and training to accomplish that goal. Inevitably, a number of seemingly important factors influence that decision-making process. There are issues relating to family, friends, and social activities, as well as the location of the institution, its size, accessibility, cost, and a dozen other details. While these matters are not to be minimized, the primary concern when selecting an educational opportunity should be "usability." The knowledge gained and the degree, certificate, or diploma earned must help the student achieve the desired career objective.

This axiom holds as true for the museum profession as it does for any other career. However, this is not to suggest that there are only a few programs that provide usable museum preparation. Selecting which program or institution to attend is a decision to be made by each aspiring museum professional. Ultimately, it is a positive professional outcome that is the measure of any program.

The significance of this career decision is reflected in the International Council of Museums *Code of Professional Ethics* (ICOM, 1996). The *Code* recommends that members of the museum profession have the appropriate academic, technical,

and professional training to fulfill their important role in relation to the operation of the museum and the care of the world's heritage. The codification of these qualifications emphasizes the multidimensional aspect of museum professionalism and reinforces the need for practical and theoretical knowledge.

Professional preparation is not just about learning; it also includes doing. Therefore, the truly masterful program should provide extensive opportunities for students to achieve proficiency in a full array of professionally oriented museum activities. Furthermore, these opportunities should be offered with qualified faculty support, including direct supervision, collaboration, and consultation of independent pursuit with post-hoc evaluation.

The preparatory programs also should stimulate critical thinking and imaginative approaches to the practices of museums. It is in this type of environment that growth is possible. Without variant thinking there may appear to be only one model for museological practice, and that attitude denies the viability of social, cultural, or scientific realignment. Meeting public service responsibilities in the evolving nature of museums requires open-minded, creative, and professionally prepared personnel eager to assume a leadership role. Undoubtedly, the students entering museum studies programs today will become tomorrow's leaders of the museums of the world.

A person trying to select the best museum studies program may find the challenge daunting. After all, there is no specialized national accreditation mechanism for museum instruc-

tion, nor is there a standardized paradigm that can be used to determine program quality. There are, however, practical measures of program success: 1) the positive academic reputation of the program; 2) the professional achievements of students who have completed the program; and 3) the distinction afforded the program's faculty and staff for their national and international participation in the museum profession.

The responsible program will blend the best of tradition with the most far-reaching vision of the future. If the traditions from which the museum and museum profession have evolved are forgotten, the purpose and identity of both will be lost. But if those traditions, no matter how meaningful, are held too rigidly, they may corrupt and become self-serving. It is the need to preserve while delimiting tradition that offers the greatest challenge to the museum community and, consequently, to contemporary museum studies programs.

This publication defines a number of pertinent issues. Its questions, comments, and ideas guide the quest for a program that will meet your needs and set the path for a personally and professionally fulfilling career in museums.

Gary Edson
Director, Museum Science Program
& Heritage Management Program
Texas Tech University, Lubbock.

QUESTIONS
to Help You
Get Started

Why am I interested in working in a museum?

You may enjoy visiting museums, have a deep interest or expertise in a certain subject matter or type of collection, or be committed to public and community service. You may be a curious person who thrives on constant learning opportunities and challenges. If so, museum work may be a good fit for you.

Museum work is fun, exciting, and absorbing. It can involve developing fascinating projects, programs, and exhibits. It can mean going to work every day in a building filled with talented people, great exhibits, and priceless objects.

But it is important to let go of any false romantic notions of the museum as an escape, a quiet respite removed from society. Indeed, museums are actively striving to be more relevant and connected to community needs, and to debunk their one-time sleepy and elitist image. They are facing many challenges as they open up to a broader public with increased expectations. In short, museums are demanding work environments. As wonderful as they are, museums are not havens from power struggles, office politics, cramped cubicles, budget cutting, and other all-too-typical woes of the working world.

Museum work is a labor of love. So, before you begin to research graduate schools, have a long talk with yourself about what it is that you love about museums and what about museum work as a career appeals to you. A passion for museums—both for what they are today and for what they can become in the future—is the most essential ingredient to a successful museum career.

Q How can I find out more about the museum profession?

It is highly recommended that you work or volunteer in a museum before you take the step of applying to graduate school in museum studies. This hands-on experience will help you to determine whether you will thrive in a museum environment. You also should:

Talk to staff in different departments at local and other museums that intrigue you. Find out what they value about their jobs and what has frustrated them. Although they are busy, most museum professionals like to talk to aspiring professionals about their work.

Recruit a mentor who will agree to coach you through your decision-making process and beyond. Mentorship is alive and well in the museum world.

Read as much as you can about museums: in newspapers, on the Internet, through museum professional organizations' publications, and the growing body of literature about museums.

Join local and national professional organizations and attend

their annual meetings. There are often volunteer opportunities that allow you to attend conference sessions free-of-charge.

"Professional organizations and their conferences are the ideal venues for gaining current information about issues that impact various types of museums. The wealth of experience that is presented at conferences enables those exploring careers in museums to find their niche in the museum world."
—Melissa Rosengard

"Before I applied to graduate school, I attended an AAM conference. I attended sessions, went to the AAM bookstore, and talked to people. The conference gave me a chance to get to know the professional community; I felt it was the perfect place for me."
—Lyla El-Shamy

Q Do I have a specific goal for my museum career? What skills will I need to attain that goal?

Start out with a goal in mind, recognizing that all good plans change as opportunities arise. For example, you may want to manage a collection, design an exhibit, head a department, or be a museum director. Seek out people in positions that appeal to you. Find out how they got there and how they recommend you prepare yourself. You will quickly discover that there is no prescribed path in the museum profession.

Some of the attributes you will need to reach your career

goal—such as patience, flexibility, energy and enthusiasm—are life lessons that can be learned in places other than graduate school. Other skills—such as communication, critical thinking, problem solving, self-knowledge, writing and research—can be significantly honed in a good graduate school, especially under the guidance of caring faculty. Awareness and deeper understanding of museum content matter, literature and theory, current issues and potential solutions, and training in specific museum-oriented skills can be attained through graduate education in museum studies.

"I would say the best thing I got out of museum studies graduate school was the opportunity to do everything: from archives management to exhibit installation. We learned that curators aren't the only ones who know something about artifacts; educators aren't the only ones who know how to teach the public; and designers don't have all the good ideas."—Ellen Endslow

Q Do I want to pursue a special area of interest or concentration? How do I decide which one?

When you are part of a museum studies program, chances are high that you will be exposed to many different facets of a museum's operations and functions. However, museum studies programs have different strengths and emphases, including (but not limited to) administration, collections management, communications, community advocacy, conservation, curating, education, fund raising, publications, technology, visitor

studies, and scholarship in a specific discipline, such as art history, anthropology, or science.

Specializing can help you to focus your education and gain specific expertise. This is valuable even if you end up working in a smaller museum where you'll do a little bit of everything.

Only a few years ago, a rule of thumb for selecting an area of specialization in museums was this: if you were "a people person," you would focus on education or administration and if you were "an objects person," you would concentrate in collections management or curatorship. Given the current emphasis in museums on teamwork, interdepartmental collaboration, and entrepreneurship, this formula now seems overly simple.

The best way to decide on an area of concentration is to learn more about different responsibilities in museums through volunteer work and research, and decide where your passion lies. Join the American Association of Museums (AAM) or your state or regional museum association's Standing Professional Committees (SPC). SPCs such as the Registrar's Committee (RC-AAM), Education Committee (EdCom), Development and Membership (DAM), and NAME (National Association of Museum Exhibitors) publish excellent newsletters as well as membership directories that can help you to identify people to approach.

"When I began working as a museum volunteer, I had the wonderful opportunity to work with a curator who involved me in all

aspects of exhibition installation. During this time, I found that I was drawn to working one-on-one with museum objects. The experience guided my decision to specialize in collections management in my museum studies graduate work."
—Anamarie Alongi

Q What are realistic job opportunities in my chosen area of specialization?

Museums are attractive workplaces. Thus, even in a strong economy, the museum job market can be tight, especially if you need to concentrate your job search in a particular geographic area. A lucky few will land their dream jobs right out of graduate school; the rest of us will need to be patient and persistent, or take a first job that isn't ideal, but is a good steppingstone.

To get an idea of what's out there, examine current job listings and note the qualifications desired. Many museums post job openings on their Web sites, and all museum professional organizations advertise openings. As of this writing, museum specialists in technology, marketing, and fund raising are in demand in larger museums. There is also a need for registrars and educators. Museums are planning many new building projects, which could mean even more staff openings. Some services such as conservation, exhibit development, evaluation, and project management are often outsourced, which means that positions in firms that consult to museums also may be available. Small museums (those with an annual budg-

et of $350,000 or less) are also looking for enthusiastic, resource-ful professionals.

"I look for employees with comparable experience in a cultural, arts, or nonprofit entity; but I also want to see that the employee has a sound liberal arts education, and M.A. level work. It is always nice to see that someone attended a good museum studies program. Obviously, an ability to write and communicate clearly is critical, and I always like prospective job applicants to send a sample of writing, or send me an off-print of an article to show that they are professionally active and serious."—Murney Gurlach

"After I completed my museum studies certificate program I attended my state museum association conference and came away with three appointments for job interviews. One week later I had two very exciting job offers."—Erin Friedberg

Q What do I need: training, a certificate, or a master's degree?

Training: There is an array of training options available for working professionals who want to brush up on skills or learn new information. These range from professional conferences to short-term courses offered by AAM, the Association of Science and Technology Centers (ASTC), the Smithsonian Institution, American Legal Institute/American Bar Association, and the Getty Leadership Institute for Museum Management, to name only a few. These courses are most helpful to mid- and senior level professionals already working professionally in museums.

They also can serve as introductions that allow those considering a career in museums to test the waters before making a longer-term commitment.

Certificates: The value of a certificate varies depending on what is involved. Some organizations give a certificate to people who pay for and attend non-accredited workshops and training sessions. Although these classes can be useful and the trainers qualified, there may be little assessment of a student's knowledge and skills. On the other hand, some certificate programs are part of a university's accredited coursework and consist of rigorous courses and evaluation of student work.

Certificate programs offered by accredited universities are appropriate for those who are already working on a related master's degree or doctorate and want to extend their graduate training to include museum studies. You should also consider a certificate program if you already have a master's degree or doctorate in a relevant area and want specific museum training in order to enhance your skills and employability.

Master's degree programs: A master's degree program focusing specifically in museum studies is more in-depth and rigorous than a certificate program. A master's degree is highly valued in the museum field since it indicates an advanced level of commitment and expertise.

"Many practicing museum professionals . . . want to work with new employees who have a passion for their work and are inter-

ested in advancing their careers and museums. They want to work with people who have the capacity for being professional and maintaining their professionalism for a long career."
—Terry Reynolds, Training for Entry-Level Museum Professionals

Q Are there educational options other than museum studies if I want to work in a museum?

Absolutely, but you may need to tailor them to your interest in museums. These options include:

◆ for administrators: a graduate degree in business administration, law, nonprofit administration, arts administration, or public administration;

◆ for collections managers: a master's degree in library science or historic preservation;

◆ for conservators: a master's degree in chemistry, conservation or textile engineering. For more information on conservation programs, contact: The American Institute for Conservation of Historic and Artistic Works, 1717 K St. N.W., Suite 200, Washington, DC 20006; 202-452-9545; fax 202-452-9328;

◆ for curators: a Ph.D. or master's degree in American studies, anthropology, archaeology, art history, classics, cultural studies, curatorial studies, ethnic studies, geology, history, public history, the sciences, or visual criticism;

◆ for educators: a graduate degree in education, museum education, child development, psychology, sociology, teach-

ing, or communications;

◆ for exhibition designers: a master's degree in graphic design, fine arts, interior design, or architecture.

"Recreation, leisure studies, and tourism are also fields with unique and valuable perspectives on museums. While I am a great supporter of the value of a museum studies degree, I don't think people should shy away from other options. Perhaps what matters most is what one is able to do with what one learns."
—Lois Silverman

Why should I pursue a museum studies degree?

A museum studies program provides up-to-date knowledge and training to prepare you to work professionally in a museum. Other benefits of a museum studies program are: the opportunity to meet and network with professionals in the field through class work and internships; studying with a community of people who share the same zeal and interests and will become your future colleagues; gaining an insider's view of museums; field trips to museums; and a curriculum with specific applicability to museums.

"Having a degree in museum studies has given me great confidence when applying for jobs. My education has prepared me for the intellectual, organizational, and practical needs of an employer. In addition, my graduate degree made me eligible for higher compensation. My degree not only prepared me for my specific area of focus, public

programming, but also made me understand how a museum func-
tions as a whole. As a result, I have been asked to participate on
numerous committees within museums that have addressed broad
concerns, such as visitor services, AAM accreditation, fund raising,
staffing/personnel issues, and mission statements."—Christie Davis

Q Is a museum studies degree valued outside of the museum profession?

Yes. People holding museum studies degrees have parlayed
their education into careers in teaching, public relations, phi-
lanthropy, theater management, consulting, law, journalism,
and business. Within the profession, they work in various
capacities—from entry level to director—in aviation, chil-
dren's, corporate, ethnic-specific, fine arts, folk arts, history,
natural history, science and technology museums. They work
in historic sites, national and state parks, galleries, halls of
fame, consulting firms, exhibit design firms, auction houses,
and other museum-related organizations.

"Recently, I was able to transfer my skills from museum work to
working for a private family foundation where, in addition to manag-
ing a public programs series, I manage a grant program for contem-
porary art. It's a great pleasure to now be in the position of provid-
ing financial support to art museums nationwide."—Christie Davis

Q How do I research different graduate programs?

◆ Review a copy of *Guide to Museum Studies and*

Training in the United States, published by AAM.

◆ Look at Web sites (www.gradschools.com is a good place to start).

◆ Send away for catalogues.

◆ Ask your colleagues, professors, and friends.

◆ Attend open houses and informational meetings hosted by universities.

◆ Arrange for an informational interview. When you have narrowed your search, call the university and make a phone appointment (better yet, an in-person appointment) with someone who can tell you more about the program.

◆ Visit the campus.

◆ Talk to current students and alumni, as well as to faculty.

How should I prepare for an informational meeting?

Many museum studies programs are competitive. You will want to make a good impression. Be on time. Cancel a meeting if you find that you can't make it (chances are someone else is waiting for the slot). Bring a resume and prepare questions in advance. Don't ask questions that are already answered in published materials unless you need clarification or more details; otherwise you will give the impression that you haven't done your homework. Be considerate about time. The person you are

meeting is busy, and you will both want to use your time well.

When visiting a program, also consider the following: How easy was it to get an appointment? How accessible is the information you are seeking?

Professors are busy, and universities handle hundreds of phone calls and requests like yours every day, but their promptness and willingness to provide information can be a clue as to how you will be treated once you become a student.

QUESTIONS
About
Museum Studies

Q What is museum studies?

Museum studies—also called museology or museum science—is the study of the role of museums in society and the different functions that contribute to that role.

These functions usually include a museum's mission, professional standards and ethics, collections, exhibitions, visitors, programs, architecture, management structure, finances, modes of interpretation, and areas of specialization. Outside factors affecting museums include the economy, legal system, political climate, demographics, and public perceptions and needs. Since it must take all of these factors into account, the museum field is becoming increasingly specialized and complex. The knowledge needed to work professionally in a museum is thus becoming more and more specialized.

Museum studies programs prepare students to hold professional positions in a variety of museum departments and functions. Museum training programs have been around since the 1920s; the number residing in universities mushroomed in the early 1970s and continues to grow.

"The entire field of how people learn and relate to museums is new and rich and it is critical to be aware of the most recent research. Much of this is standard museum education; it is about

being visitor-centered. My belief is that everyone in the organiza-
tion who is in any way involved with the public needs to under-
stand how best to meet their interests and needs."
—Leslie Bedford

What is covered in a museum studies curriculum?

There are no industry-wide standards in museum studies pro-
grams. Curriculum varies widely. Sensing that university programs
did not always meet the needs "out in the real world," the AAM
Committee on Museum Professional Training (COMPT) recently
surveyed the chairs of the association's other Standing Professional
Committees to find out what they looked for in entry-level muse-
um employees. A report written by Terry R. Reynolds in 2000 list-
ed core expectations and correlated these expectations to recom-
mended topics for museum studies course work.

The topics included: the general professional responsibili-
ties within a museum and the inter-relationships of these
responsibilities, ethics, laws and regulations impacting muse-
ums, museums as educational institutions, collections care and
conservation, the history of museums, finances, governance
and organization, and museums and technology.

Other course topics can include: exhibition analysis, devel-
opment and design, learning theory, preventive conservation,
and evaluation methods.

What is the distinction between museum studies and . . .

◆ arts administration?

Arts administration programs stress understanding arts and cultural organizations of all types and developing management, marketing, and financial skills.

◆ curatorial studies?

Curatorial studies focuses on the roles and responsibilities of curators in art museums and art galleries. Courses emphasize connoisseurship, theory of the visual or decorative arts, and exhibition analysis and design.

◆ cultural studies?

Cultural studies is an interdisciplinary course of academic study that draws from the fields of anthropology, sociology, gender and post-colonial studies, feminism, literary criticism, history, and psychoanalysis in order to discuss texts and cultural practices.

◆ media studies?

Media studies focuses on producing, designing and critiquing multimedia projects, including television, radio, film, the Internet, computer-aided design, and other technologies.

◆ museum education?

The field of museum education is distinct from museum studies. Museum education programs focus on how people learn in museum settings. Students are encouraged to develop and implement effective strategies that empower visitors to experience museums more fully.

◆ public history?

Public historians preserve, interpret, and exhibit culture and heritage at history museums, historic sites, and in the media. Public history combines the academic discipline of history with less traditional methods like oral history, documentary film, and exhibits.

◆ historic preservation?

Historic preservation programs prepare students for careers in preserving and interpreting historic buildings, furniture, sites, and landscape.

Clearly, there is overlap between museum studies and all of these areas. Museum studies touches on many of the issues explored in these programs, applying them to museums of all types.

Q How do museum studies programs operate within academic institutions?

That depends on the program. Some universities have an autonomous museum studies department that offers specialized curriculum or coordinates different courses across departments. Other universities offer museum studies courses or specializations within a more traditional academic department, such as art history, history, or anthropology. Still others offer training through their campus museums. As a result of where they are housed and how they are financed, some programs are oriented toward certain types of museums.

"It is extremely important that the university views the museum studies program as equal with other academic programs. The director may teach some classes, but the program should be the top priority. In some instances, the director of the program is also the director of a campus museum, an arrangement that may facilitate practical experiences for the students but may also overload the director unless there is a sizable staff to assist."—Jane Glaser, author, Museums: A Place to Work

"Potential students should ask questions about cross-campus cooperation. It's always better in theory than in practice in my experience."—Kristin Szylvian

Q How do a Ph.D. or M.A. in an academic discipline and a master's in museum studies compare?

Graduate work is challenging no matter what you study! Ph.D. study will prepare you to research and analyze at a very high level, and focus you in a specific discipline. Since museums educate the public about content, this in-depth knowledge can be beneficial, especially for a curator or an educator. Most Ph.D. programs train their students to become scholars and hold tenure-track faculty positions in academic institutions. However, as tenure-track positions are less and less available, Ph.D. programs are looking at museums as viable places of employment for their graduates. A Ph.D. usually takes about five or more years of full-time study to complete.

An M.A. in a content area takes less time than a Ph.D. and will usually involve coursework and a culminating thesis. The focus will be on research and analysis in a discipline area. Coupled with a certificate in museum studies, an M.A. in an academic discipline can prepare students to work professionally in a museum that focuses on that discipline.

A museum studies degree will prepare you on a more practical level to work professionally in a museum. You will be exposed to museums of all types and to current issues that museums are grappling with. A museum studies degree usually takes one to two years of full-time study to complete.

You will need to decide which course of study works best for you. Here are two perspectives:

"We firmly believe our students are better served by the depth of knowledge they receive in more traditional disciplines. For example, art museums that I know look for staff members with a keen understanding of art history. We do not see museum studies as a discipline, rather as a professional course of study."—Susan Baldino

"A museum studies degree is a content degree. The content is museums. The museum studies degree should allow graduates to go into a museum situation, instantly become functioning members of a staff and advance in the organization. Museums are unique organizations and students with only disciplinary training

lack an understanding of museums as functional organizations, which limits their initial contributions."—Hugh H. Genoways

How valuable is a museum studies degree?

This question has been hotly debated in conferences and list-servs. The consensus seems to be this: Graduate education is highly valued in the museum profession. A museum studies degree is not necessary for a successful career in museums. However a graduate degree in museum studies can provide an advantage on the job market and a strong foundation for success.

Some of the debate occurred because in years past, before museum studies became popular, many museum professionals learned their trade "on the job" and were wary of new graduates who had received formal training. Others believed that advanced study in a more traditional academic discipline was more credible than museum studies, which is interdisciplinary and non-traditional. Today, as more and more museum studies graduates influence the direction of museums, these feelings have largely (although not entirely) dissipated.

"Plain old 'experience' in the field is not a 'wrong' way to go; however museum studies offers the future museum professional comprehensive knowledge of the museum as an institution and a sounder foundation for advancement in the field."—Susan Baldino

QUESTIONS
to Consider
When Researching
Museum Studies
Programs

GENERAL INFORMATION

Q Is the university accredited?

Accredited universities undergo a rigorous evaluation process that ensures that coursework and university processes meet an outside set of academic standards. If you choose to attend a program at a school that is not accredited, your coursework cannot be transferred to an accredited college or university.

Q What degree is offered?

Determine whether you want a certificate, a master's degree in museum studies (either a master of arts or a master of science), or a master's degree in a discipline area with a specialty or additional certificate in museum studies. Make sure the program you are researching offers the degree you want.

Q What are the requirements for admittance into the program?

Applying to graduate school is a competitive process. Several people, including an admissions committee, will review your application. The admissions committee may be comprised of museum studies faculty, administrators, alumni, and/or current students. Be sure that you understand and follow the application guidelines set by each university. Here are a few general rules:

◆ Personal essay: Most schools want to see how you present yourself in writing. If an essay is required, submit one that is persuasive and well written. Proofread it. Send the right essay to the right university. (Every year at John F. Kennedy University, we receive at least one essay that is addressed to a different university!) Remember, admissions committees read hundreds of essays each year; make sure that yours stands out.

◆ Deadlines: An applicant who cannot meet a deadline will make an unfavorable impression on an admissions committee. Confirm that your letters of recommendation, GRE scores (if required), and transcripts have arrived on time. If you don't have a B.A. yet, make sure the university to which you are applying knows when and how it will receive official word that your undergraduate degree has been posted onto your transcript.

◆ GRE's: Some programs will require you to take the Graduate Record Examination (GRE). For more information on deadlines, testing sites, and how to study for this exam, contact: GRE-ETS, P.O. Box 6000, Princeton, NJ 08541-6000; 609/771-7670; www.gre.org.

◆ Undergraduate Degree: Graduate schools require proof of an undergraduate degree from an accredited university, usually with a grade point average of B or better. If your grade point average is below a B, don't cross your fingers and hope that the committee won't notice. Explain in your essay why your grades suffered and how you intend to overcome any academic problems once you are in graduate school.

Q Is an applicant interview required?

Many programs want to personally interview applicants. They value one-on-one interaction with participants in their program and they want to see how you present yourself in-person. Some programs interview applicants as a group in order to look at how the applicants behave in a group situation. In either case, an in-person interview provides you with a good opportunity to learn more about the people involved in the program, see the university's facilities, and make a persuasive case for your admittance. If possible, try to go to the interview in person, rather than conduct it over the phone. In either case, be prompt, polite, listen well, and prepare questions in advance. If you are interviewing in person, dress appropriately, bring a portfolio of your work if you have one, and remember to use good eye contact.

"Be prepared to explain what strengths you would bring to the program. The most competitive graduate programs are looking for a diversity of interests and a particular spark that sets an individual apart from others. Potential students must be able to articulate why they are interested in museum work and why they believe a particular program is the right fit for them."—Gretchen Sorin.

What are the requirements for graduation?

◆ Coursework. Check to see what courses you need to take, what the prerequisites are, where and when they are offered, and how your performance will be assessed. Is there a core curriculum? Are there electives? Are there specialization courses? Will you write papers, take tests, do group projects or lab work, and/or make oral presentations? Will you be graded, or take courses pass-fail?

◆ Duration. Most museum studies programs are one to two years in duration, provided students attend full-time. Some programs have part-time options for those who want to work more slowly toward their degree. Find out the average length of time it takes for students to graduate.

◆ Residency requirement. Typically, graduate schools want students to live in the community where they go to school in order to build camaraderie and maximize the educational experience. However, other models include intensive weekend classes; evening classes designed for working adults; and online museum studies classes. To determine which is best for you, think about the following: How often do classes meet? On weekends? Weekdays? Evenings? Where do they meet? Do you need to live "in town" during the duration of the program, or can you live somewhere else and fly in for special classes, workshops, and assignments. Is distance education the best alternative for your schedule and needs?

◆ Writing requirement. Writing clearly and cohesively is critical to a successful museum career. Some museum studies programs require students to pass a writing requirement that

demonstrates their ability to write effectively. These programs should offer assistance to help students perfect their writing skills.

◆ Language requirement: Some programs (usually those with a classics or art history focus) will require you to pass an examination that shows competency in one or more languages other than English. Make sure you have a strategy for meeting this requirement.

◆ Thesis, portfolio, or final examination requirement: A final examination will probably involve a meeting with a faculty committee, which will ask questions about your academic work. A portfolio is a compilation (with analysis) of the work you have accomplished in your program. A written thesis or project is a comprehensive and original written document that examines an issue in great detail. Some programs require an oral presentation of the research in addition to the written report.

Graduate programs usually require a concluding activity that allows graduating students to synthesize what they have learned. Some programs, however, feel that the credit hours devoted to a comprehensive thesis or final project are best used elsewhere in the curriculum. If the program you are interested in requires a thesis, be sure you will receive adequate feedback and faculty support. Past museum studies theses, available in university libraries, are good indicators of the level of work that is expected.

"Thesis and project work give students the time to focus intently

on museum challenges and philosophies. Once you're working, this sometimes gets pushed under the rug for the purely pragmatic."—Greta Brunschwyler

◆ Internships. Note that some programs require more than one internship. Through internships, students can experience more than one institution and get a big picture view of the museum profession, rather than become enmeshed in one organization's culture. More details about internships are discussed in the section that follows.

INTERNSHIPS

What do I need to know about internships?

The two most important things you need to know about internships are:

◆ The experience of a graduate-level internship is often cited as the most valuable part of graduate education in museum studies.

◆ As stated so well by the New England Museum Association, "an internship is fundamentally an educational training experience for both students and museum staff. It's not a source of cheap labor."

Internships allow you to put theory into action, strengthen your resume, and expand your network of museum professionals. Even if you already have museum experience, internships expand your knowledge and experience, exposing you to new aspects of the museum. They also give you the chance to experiment without having to make a long-term commitment. They help you to build experience, confidence, and contacts. Since they are so important, it is critical to be sure that the internship component of a museum studies programs meets your needs.

"I stand as an example of someone who benefited enormously from my graduate internships. Contacts I made nearly 20 years ago as a museum intern remain valuable today."—Kristin Szylvian

Here are some questions to consider:

Q Is there a required internship component?

Some programs require internships; others
do not. If a program you are considering
doesn't, find out why. The professors may feel
that an internship is best arranged "off the academic clock." If
an internship is not required, you will have to consider
whether you want to arrange an internship on your own in
order to gain valuable experience.

Q How are internships organized, supervised, and evaluated?

An internship is a partnership between the student, the muse-
um, and the university. This means that the student will gain
professional experience, the museum will gain valuable input,
and the university will monitor the quality of the experience.
You will be expected to complete professional-level work,
although the wise intern will always pitch in where he or she
can make a difference and be part of the team.

For internships, universities may require some or all of the
following:

◆ meeting with faculty to assess a
student's needs, desires, and professional goals;

◆ identifying and approving an appropriate site,

supervisor, and project;

◆ developing a shared understanding (possibly in writing) of what the student intends to accomplish during the internship;

◆ submitting a contract, signed by the student, the museum supervisor, and a faculty member;

◆ evaluation on the part of the museum, possibly a letter of reference, an interview, and/or a written evaluation

◆ documentation on the part of the student, usually a journal, diary, logbook, portfolio, paper, and/or oral presentation

◆ a faculty site visit.

Q How are students placed in internships?

Find out how students arrange their internships. What role does the program staff and faculty play in helping to place students? What kinds of museums do students work in? Do students do internships in museums accredited by the AAM?

Q How much time must the student commit to the internship? Is this a meaningful amount of time?

The internship should allow at least some sustained full-time contact with the museum. The more time you can spend immersed in the museum's environment, the more responsibility you will be given.

Can I get a paid internship?

Sometimes museums offer a salary, stipend and/or housing to their interns. These paid internships are often advertised through museum studies programs' bulletin boards and "job books." Paid internships have a clear advantage—they are paid. They also have disadvantages. First and foremost, some universities will not give credit for paid internships, because they feel that paid arrangements compromise educational goals. Secondly, a paid internship may impact a student's financial aid status. Internships are a unique opportunity to benefit from once-in-a-lifetime educational experiences. Even if your university allows you to be paid by your internship sponsor, it may be worthwhile to forgo a paid internship opportunity for an unpaid one that is more closely aligned to your professional goals. If you need to be paid by your internship site to make ends meet, make sure your university will allow you to receive credit for your paid work.

"Our expectation of internship sponsors is that they will work with us to provide a truly educational experience for our students. In return they receive the benefit of the students' time, energy, and skills."—Carlo Lamagna

Are the internships in-town or out-of-town?

There are museum studies internships in museums all over the world. Find out what kinds of internships students have participated in and what their experiences have been.

Q Are interns ever hired by the participating museums after completion of the internships?

Museums are certainly not obligated, nor are they in a position, to hire every intern who comes their way. But, when staff positions do open up, they will often turn first to the people who have already demonstrated their commitment and talent. Find out whether interns from the programs you are researching have ever been offered positions as the result of their internships. This will be a clue as to how well the program is respected and how well it prepares its interns.

FACULTY

What is the background and training of the program's faculty?

It is critical that faculty have direct museum experience. Check to see where faculty has studied and with which museums they have been involved. Do they have doctorates or advanced training in fields such as law, business, museum studies, or education?

No amount of training guarantees that faculty will be engaging teachers. Ask students and alumni to share their experiences with you, and be sure to get more than one opinion.

"It's important that faculty have practical experience in museums, but that's not enough in itself. Good faculty need theoretical sophistication and a clear understanding of relationships between theory and practice. Students are equally ill-served by abstract theory with no discernible implications for practice, and by skills training with no theoretical context for making sense of it all. The field is changing rapidly, and faculty need to equip their students with a coherent theoretical structure for diagnosing change processes in their museums and for leading change in creative new directions."—Jay Rounds

Q Do faculty work on the front lines or on the cutting edge of museum activity? What areas is faculty researching in the museum field or in their academic discipline?

One of the exciting aspects of the museum profession is that it is constantly changing. Faculty members should not be relying on out-of-date information. To be effective, they must be active in some aspect of the museum profession, such as research and writing, curating or developing exhibits, working in an on-campus museum that is open to the public, and/or serving on a board or in a professional position in a museum. They should be members of local, regional, and/or national professional organizations in their areas of interest, attending and/or speaking at those organizations' conferences, have an up-to-date knowledge of museum literature and thinking, and be in contact with their professional peers and colleagues. If you want access to museum professional networks, check to see whether faculty can provide this access for you.

Some faculty may be more engaged in scholarly activity in an academic discipline than in the museum profession. If you are already active in the museum profession, you may decide that you want more exposure to the scholarship in a discipline area. You can learn a lot by reading faculty publications and research projects and determining what appeals to you.

Qoes the program utilize outside practitioners to enhance the learning experience?

Practitioners from different museums can bring fresh perspectives to the classroom and are thus important contributors to a museum studies education. Your program should expose you to professionals in the field.

"The most valuable aspect of my museum studies education was exposure to professionals in the field and educational theories that applied directly to museums."—Karen Nelson

Qs there a point person for the program? Is there staff support?

It is important that the program has leadership that is advocating for and supporting museum studies students. Is the program run by: a designated full-time or part-time chair, an academic committee, a chair with other responsibilities, or a faculty member in a larger department who coordinates the program?

You also will find yourself working with other university staff connected to the program, including administrative staff. Consider the kinds of support and counseling you think you will need and compare that to the staff support available in the program.

STUDENTS

How many students are enrolled in the program at any one time? Who are they?

The number of enrolled students will determine class size, the amount of individual attention you will receive, and whether or not there will be a group of colleagues for you to get to know. You also will want to know students' backgrounds, age range, and experience.

Are students satisfied with the program?

The easiest way to gauge this is to talk to students and alumni. Most students will be forthcoming and respond to your questions honestly. Ask to sit in on a class, and how to get in touch with students and alumni. Many programs host alumni events at AAM's annual meeting and other conferences, which are open to all delegates and are a great way to meet alumni.

Are students engaged in the museum profession?

Find out if students are already working in paid positions in

museums and how they got their jobs. Also, inquire whether they are involved in local professional organizations or attend conferences (although expensive, conferences offer scholarships, volunteer opportunities and price breaks for students).

CURRICULUM

What is the philosophy of the program?

Look at the program's mission statement and curriculum, as well as the work of faculty members. Are they emphasizing issues that are important to you? Is the program traditional or forward-thinking and innovative? Is the balance between idealism and pragmatism comfortable to you? How much time is spent on site in museums? How much time is spent in the classroom?

Be sure that the program offers the following:

◆ a core curriculum

◆ site visits to and classes in museums as a regular part of the curriculum;

◆ opportunities to meet with practicing museum professionals, such as conservators, curators, educators, directors, etc.

Is there a commitment to diversity?

As public institutions, museums have an enormous responsibility to reflect our diverse society. However, museums are still struggling with how to become more representative of different viewpoints and experiences, with many woefully lagging behind in this area.

If you are committed to engaging with the complex issues of

diversity in museums, consider the following about programs you are researching: are there students, faculty and guest lecturers of color? Do course offerings and readings allow for dialogue about diversity? Is the community diverse?

What is the mode of instruction?

How do you want to learn about museums: through listening to lectures, engaging in hands-on activities and lab work, using the Internet, going on site visits, working on projects by yourself, working on team projects, actively discussing and debating with classmates and professors, or a combination of all of these methods? Find out what teaching methods are favored by the program by looking at syllabi, talking with students, and sitting in on classes.

How often are courses offered? Who teaches them?

Catalogues will list approved courses by title. It is very important to determine how often the courses are actually offered and the qualifications of the instructors teaching them.

How often is curriculum revised?

Since the museum field is dynamic, curriculum should reflect up to date readings and topics. There are some classic texts in the field, but there are also new texts that reflect innovative

theories and practices. Look at syllabi and reading lists for current classes in the university's library. Universities often post syllabi directly on their Web sites. Be aware that syllabi are proprietary.

"Make sure the curriculum is constantly reviewed and updated to identify current issues of relevance, such as technology and professional ethics. The program must develop new courses and other means to incorporate these new issues into existing curriculum."—Ildiko P. DeAngelis

Museum Resources

Are there on-campus museums?

On-campus museums can be tremendous assets to a university community and a museum studies program in particular. But the presence of on-campus museums does not necessarily mean that they are integrated in the museum studies curriculum or even open to the public. If the exhibitions and programs offered by an on-campus museum interest you, ascertain what role the museum and museum personnel play in the program. Inquire whether museum studies students have the opportunity to participate in exhibition development, collections management, and other vital areas and whether they have access to such equipment as conservation labs.

Does the program have ties with other museums in the community?

Does the university have cooperative agreements with other museums? Are site visits to museums a regular part of the curriculum? Do personnel come to class as guest speakers and jurors for student projects? These kinds of arrangements can benefit museum studies students enormously.

What is the museum community like?

Visit the museums in the community in which you plan to study. Is there sufficient variety, quality, and innovation to suit your tastes? Do professionals whose work you admire lead them? Are there active local associations of museum professionals? Learning museum studies in a large metropolitan area has the advantage of offering a vast palette of museums for projects, visits and in-depth study. However, museum professional communities in smaller communities might have more innovative practices and be more readily accessible to students.

TECHNOLOGY

What do I need to know about technology?

Familiarity with word processing, data management, the Internet, and e-mail will be vital to your success in graduate school as well as in the museum profession. Technological advancements affect every facet of a museum's operations. If you are unfamiliar or uncomfortable with information technologies, check to see if there are courses available to museum studies students. If you don't have access to a computer, make sure the university has a computer lab open to students. Some museum studies programs incorporate technology courses directly into their museum studies curriculum so that the curriculum is museum-specific; others use the expertise from their universities' computer science or multimedia departments to offer this training.

An excellent resource is the Museum Computer Network (www.mcn.edu), which sponsors ongoing training, an annual conference, and publications.

What about distance learning?

Distance learning is still a relatively new aspect of university education. Distance learning is defined as the acquisition of knowledge and skills through mediated information and

instruction. It is commonly described as courses that use online lectures, communication, conversation and assessment. The obvious advantage is that online education costs less than classroom education. Other advantages are that students can learn at their own pace, in their own time frame, and without having to commute. Thus far, research shows that students studying certain subjects online perform the same on tests as students who learn in the classroom. However, before we rush to bulldoze traditional universities, it's important to point out that distance learning has strong drawbacks. The interpersonal dynamic of the classroom is hard to replace, especially when applied to a field like museum studies that is devoted to public space, hands-on interaction, working with people, and learning from objects.

"When done well, distance education can go a long way to addressing both individual and institutional training needs. It can enable participants to gain access to courses that are unavailable or unaffordable. It can allow participants to balance busy professional and personal schedules more effectively. Going beyond the classroom environment, it can situate learning in the workplace and link learners around the world in interactive teaching/learning partnerships."—Joy Davis

"Looking closely at objects is an essential component of our work and the virtual experience is not a substitute."—Gretchen Sorin

CAMPUS RESOURCES

What other university services should I be thinking about?

First and foremost, be sure that the university's library is accessible and has museum studies materials. Then consider whether the following will be important to your success as a graduate student: location, academic support center, campus museums, computer lab, writing and editing assistance, services for students with disabilities, financial aid, resume-writing and job placement assistance, parking, athletic facilities, health care, counseling, dormitories, housing office, married student housing, student lounge, student cafeteria, student publications, clubs and activities.

"Universities offer unexpected opportunities that amplify the educational content of a museum studies program. Prospective students should make their decisions based on the quality and strengths of the museum studies program, but they should not ignore the larger university community and its many opportunities."—Stephen Lekson

FINANCES

How much will a graduate degree cost?

Attending graduate school is one of the best personal invest-
ments you will ever make in your life. However, you will feel
more comfortable about making this investment if you know
the financial costs up front.

There are three costs to a graduate education in museum
studies: direct costs, opportunity costs, and future salary con-
siderations.

Direct costs: This is the direct cash layout necessary for any
educational endeavor, including:

◆ tuition (remember, most universities increase
their tuition every year),
◆ books,
◆ supplies (paper, computer access, materials for
exhibition courses, etc.),
◆ other standard university fees, and
◆ transportation to and from school.

Most universities have financial aid offices that offer loans,
scholarships, assistanceships, work-study programs, and other
ways of deflecting these direct costs. Some employers will pick
up some of the costs of tuition and allow release time for grad-

uate education. There are also outside sources of scholarship support for which you may be eligible . A good resource is the Foundation Center Library (www.fdncenter.org).

Opportunity costs: For many people, full-time graduate education is a great opportunity to leave the "working world" and concentrate on studies. This is known as an "opportunity cost"—the time you are in graduate school is the time you could have spent earning a salary. The advantage to not holding an outside job during graduate school is that you will be able to immerse yourself in your studies and university life. The disadvantage is, of course, financial, as well as the loss of the opportunity to apply your knowledge in a museum as you are learning it. If you need a salary while you are in school, find a graduate program that is set up so that students can work full- or part-time while they are in school.

Salary considerations: Like teaching, artistic endeavors, and other kinds of public service, museum work is enormously fulfilling and attracts dedicated and passionate professionals. However, museum professionals are paid less than their colleagues in the for-profit sector. It may be difficult to find your first professional position and relocate to areas with a high cost of living. Level of pay will depend on the position, the marketplace in the area in which the museum operates, and the type and size of the museum. Research salary levels in publications such as AAM's monthly newslet-

ter *Aviso* and be sure that you are comfortable with standard salary ranges in the profession.

POST-GRADUATION

Q **How do students get jobs in museums?**

Inquire about where alumni are working and how they got their jobs. Some museum job openings are posted; however, other positions come via word of mouth and networking. The reputation of a program and a network of alumni and professors can significantly help students find suitable employment after graduation. Faculty and alumni can also recommend students for conference presentations, and post-graduate scholarships and encourage them to publish and participate on committees and the like. Find out what kind of role the program plays in helping to launch students' careers.

Q **Are there job placement services and career counseling?**

Many universities have career centers that post job openings and offer resume advice and other kinds of career counseling. Since museums are such specialized places of employment, museum studies faculty should also be available to students and alumni making career decisions. Make sure you will get the kind of assistance you feel you will need after graduation.

Q What are alumni doing five or 10 years after they graduate?

Do alumni advance in their jobs? Do they stay active in the museum world? Do they publish or otherwise contribute to the museum profession? Do they stay involved with the university?

Q Is there an alumni association?

Many programs try to help their alumni stay in touch with one another through receptions at AAM and other conferences, newsletters, parties, and post-graduate lectures, courses, workshops, and online journals, and list-servs. This kind of support will let you know if there is an *esprit-de-corps* that lives on long after graduation day.

ARE YOU PREPARED
to Expect the Unexpected?

Graduate school is a journey . . . a time for personal exploration and growth. In the best cases, you will be exposed to new people, new ideas, and new ways of thinking. Don't be surprised if you enter with one idea of what you want to do and leave with a whole new vision.

There's more than one answer to these questions
Pointing me in a crooked line.
And the less I seek my source for some definitive
The closer I am to fine.
—Indigo Girls, "Closer to Fine"

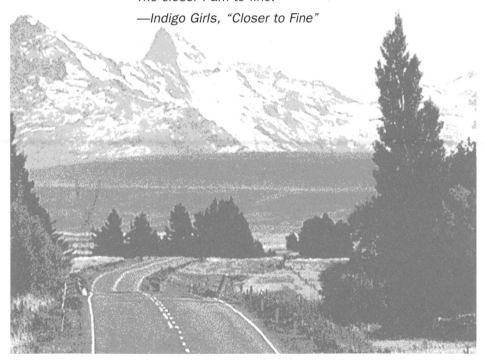

RESOURCES

1999 Guide to Museum Studies and Training in the United States. (Washington D.C.: American Association of Museums, 1999).

AAM Committee on Museum Professional Training (COMPT). For current information about COMPT, go to the AAM home page at www.aam-us.org and click on the link for Council of Standing Professional Committees.

American Association of Museums, 1575 Eye St. N.W., Suite 400, Washington, DC 20005; 202-289-1818; fax 202-289-6578; www.aam-us.org.

Center for Education and Museum Studies, Smithsonian Institution, Washington DC 20560; 202/357-3101.

Danilov, Victor J. *Museum Careers and Training: A Professional Guide* (Westport, Conn.: Greenwood Press, 1994).

Edson, Gary. *International Directory of Museum Training.* (London, New York: Routledge, 1995).

Glaser, Jane R. *Museums: A Place to Work* (New York: Routledge, 1996).

Haworth, J. G., and Conrad, C. F. *Emblems of Quality in Higher Education: Developing and Sustaining High-Quality Programs* (Boston: Allyn and Bacon, 1997).

International Council of Museums. "Curricula Guidelines for Museum Professional Development": http://museumstudies.si.edu/ICOM-ICTOP/index.htm, accessed Jan. 4, 2001.

Reynolds, Terry R. Training for Entry-Level Museum Professionals: A Report Prepared for The Committee on Museum Professional Training (unpublished, April 2000).

"Risk and Opportunity: The Museum as Career Choice," *Museum News*, July/August 1998.

Spiess II, Philip D. "Museum Studies: Are They Doing Their Job?" *Museum News*, November/December 1996.

Standards and Guidelines for Museum Internships (Washington, D.C.: American Association of Museums, 1993).

Wagner, Robin. "Careers for Ph.D.'s in Museums," *The Chronicle of Higher Education*, Oct. 13, 2000.

INDEX